In Greek myth, the Pegasus, symbol of imagination and soul, springs fully formed from the neck of the slain Gorgon Medusa, as number itself springs fully formed from the division of Unity. The Pegasus' first act is to fly to Mount Helicon, home of the Muses (whence we derive the word 'music'). Striking his hoof upon the mountainside, he frees the Springs of Inspiration.

First published in the UK in 2021
by Wooden Books LTD, Glastonbury.

Library of Congress Cataloging-in-Publication Data
Tetlow, A.
The Diagram

Library of Congress Cataloging-in-Publication
Data has been applied for.

ISBN-10: 1-952178-29-0
ISBN-13: 978-1-952178-29-0

Designed and typeset in Glastonbury, UK.

Printed in China on FSC® certified papers by
RR Donnelley Asia Printing Solutions Ltd.

THE DIAGRAM

HARMONY IN GEOMETRY

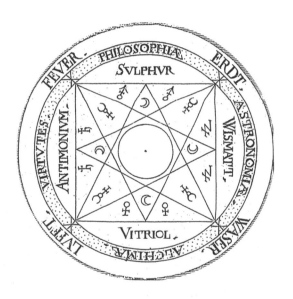

Adam Tetlow

"I am One transformed into Two;
I am Two transformed into Four;
I am Four transformed into Eight;
I am after this, One."

Saying of Thoth from the Coffin of Petamun, c.185 AD

Thanks to Haifa for her ongoing love, humour and support, to my family, Idris, Saena and Oak, Liz and Trent, Mum & Dad, & to my friends and family in Britain and overseas. Special thanks to my editor and co-illustrator John Martineau and to my teachers John Neal, the late Keith Critchlow, and Paul Marchant. I am indebted to the books of R.A.Schwaller de Lubicz and Hans Kayser and to Patterns of Eternity by Malcolm Stewart, Beyond Measure by Jay Kappraff and By Hand and Eye by George Walker & Jim Tolpin. Thanks to Daniel Docherty, Leon Conrad, Jon Allen, Michael Schneider, Michael Frenda, Ling Duong, Sara Hall, David Heskin, Aloria Weaver, Tom Bree, Earl Fontainelle, Adam Sommer, Hugh Newman, Christine Rhone, Howard Crowhurst, Robert Temple, Robin Heath, Desmond Lazaro and Katya Monos. Picture credits: engravings opposite p.1 from Académie de l'Espée by Gerard Thibault d'Anvers, 1628, pp.42-43 George Walker & Jim Tolpin, pp.10,& 54-55 Patrick-Yves Lachambre, p.58 after a graphic at harmonik-zentrum-deutschland, pp.39, 52 & 56-57 from Hans Kayser's Manual of Harmonics, p.28 after Lucie Lamy, pp.35 & 51 Santa Maria Novella after Kappraff, p.56 after Willibald Limbrunner, p.45 after Robert Chitham, pp.38-39 from Temple of Man by R.A.Schwaller de Lubicz, p.56 Daisy Martineau. Look out for Ancient Metrology, this book's partner, also published by Wooden Books. Courses at www.adamtetlow.net or www.imaginalgeometry.com

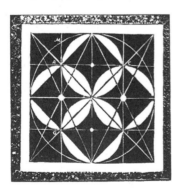 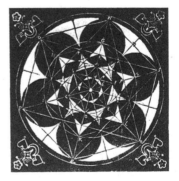

ABOVE: *Geometric 'seals' by Giordano Bruno [1548-1600], used for 'mathesis' - number understood though contemplation.* LEFT: *the 'Figure of Love,' a partial drawing of the Diagram.* RIGHT: *the 'Figure of Intellect,' showing nested star hexagrams.* TITLE PAGE: *Alchemical version of the Diagram, from Cabala, Speculum Artis Et Naturae in Alchymia by Stephan Michelspacher (1654).*

Contents

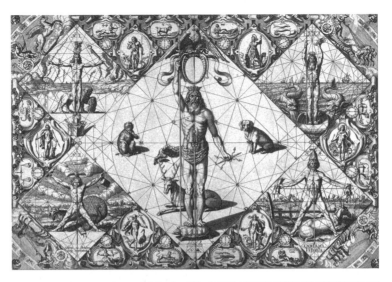

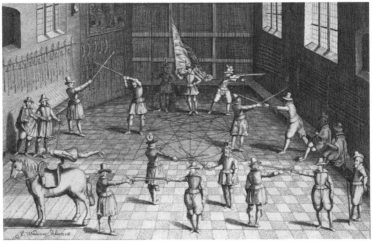

INTRODUCTION

R EALITY, like a lightning bolt, illuminates a landscape of eternal Forms, constants that are the mind of Nature, the living Cosmos and its choir of beings; love, consciousness and number. The perennial philosophy, already ancient in the time of Pythagoras, asserts that these principles are themselves the wake of a singular phenomenon, the indivisible source we name Unity, the original quality, without quantity or definition.

To study number is to study Unity, and the archaic curriculum frames this pursuit through the qualitative behaviour of numbers in relation to each other as the arts of Arithmetic, Geometry and Harmonics. Fragments of this original science, scattered through the ruins of ancient sites, traditional craft methods and surviving early texts of philosophy and mathematics, show the central position occupied by Harmony, the comparison or synthesis of fractioned parts. Yet, as these sciences passed from Egypt to ancient Greece, their symbolic roots were lost in the labyrinths of time and the means to integrate them as a single study was obscured.

The quest to rediscover this fusion of the number arts led to the harmonic-geometric work of Johannes Kepler, and the geometric-harmonic equal-tempered scale, although the alchemical solution of the philosophers remained elusive. And yet, from the Diagram drawn in a humble square a living gesture of Universal Harmony is revealed, illuminating the intentions and goals of ancient societies across the planet, recalling its status accorded by Socrates: the Highest Good.

FROM ONE TO MANY
division as creation

Creation begins with the contraction of Eternity. Unity, through a self-creative division, coagulates into different but complementary parts. This original scission or causal separating power has been known to philosophers through the ages. Plato [425–347BC] called it *'the perfect cut'* because the relation of the smaller part to the larger is the same as the larger part to the whole (*shown below*). We call it *phi*, φ, the golden mean.

Much has been written on the application of phi in nature and mathematics, but its function as the mystical cause of number itself, as the fractioning or punctuation of the infinite, is often disregarded. It is the living word, the seed syllable and song of creation, opening the origin myths of so many human societies.

Plato describes the World Soul, *'the fount of ever-flowing nature'*, as fashioned by the Cosmic Craftsman, Form or Unitary Ratio, from two rings joined in an 'x', *'containing all the measures and harmonies'*. This form is the *'Tetractys'*, a map of related vibrations or tones made from multiplying and dividing the numbers 2 and 3 to create different octaves containing the same interval relationships (*opposite, top*).

The tonal number relationships in the tetractys give us Pythagorean tuning. Expressed as whole numbers, they create the octave (12:6), the fifth (9:6) and the fourth (8:6), as well as the intervals that unite them into the most common musical scale (*opposite, bottom*), whose vibrations are for Plato *'akin to the orbits in our souls'*.

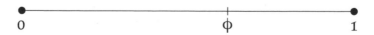

0 φ 1

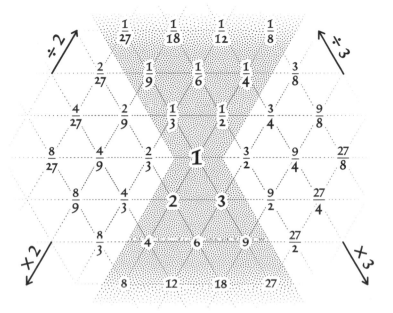

ABOVE: The Tetractys or World Soul holds all possible relationships between 2 and 3. Ascending to the right divides by 2, descending to the left multiplies by 2. Ascending to the left divides by 3, descending to the right multiplies by 3. Thus in different octaves the same intervals appear.

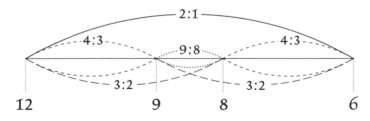

ABOVE: The Pythagorean musical scale expressed as whole numbers. The doubling of 6 to 12 is the octave, 2:1; 9, the fifth, 3:2, is the arithmetic mean of 6 and 12; 8, the fourth, 4:3, is the harmonic mean of 6 and 12 (see overleaf for more on the means). 9:8 is the whole tone.

GEOMETRY AND HARMONICS
binding the cosmos together

Ratio occurs between two numbers (*a:b*). *Proportion* is a continued sequence of a ratio (*a:b::c:d*). Plato's friend Archytas of Tarentum [428–347BC] called the science of ratio and proportion *logistikon*.

For Plato, the living world was ensouled and embodied through the action of the three means: Arithmetic, Geometric and Harmonic, shown opposite as continued proportional sequences. Plato understood these means as forces binding opposing qualities together.

The *Arithmetic Mean* is half the sum of the extremes *a* and *b*. In the *Geometric Mean*, the square of the mean equals the product of the extremes. The *Harmonic Mean* is twice the product of the extremes divided by their sum. It is fitting that the causative force of phi contains all three means in a sequence of any four terms (*shown opposite*).

Thinkers in medieval Europe prized the understanding of the means. The ancient game *Rithmomachia* (*below*), once as popular as chess, is won by arranging numerical counters in sequences of all three means.

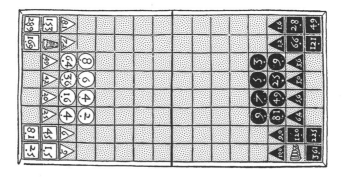

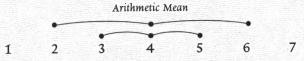

ARITHMETIC SEQUENCE
showing how the arithmetic mean occurs between terms

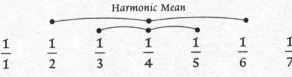

HARMONIC SEQUENCE
showing how the harmonic mean occurs between terms

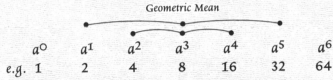

GEOMETRIC SEQUENCE
showing how the geometric mean occurs between terms

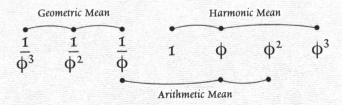

GOLDEN SEQUENCE
embodies all three means between four terms

THE DIAGONAL
the birth of geometry

Diagonals of geometric forms display remarkable rational dividing properties, even when their length is unresolvable in whole numbers.

A *perpendicular*, or line at right angles, taken from a rectangle's corner to its diagonal creates a smaller rectangle with the same proportions, known as a *gnomon* (*opposite, top left*). The centre point of any rectangle may be found by its crossing diagonals, and this crossing property continues with semi-diagonals, starting a process of harmonic division of any rectangle's edges (*opposite, top right*). A *transversal line* makes use of the diagonal's nature to transfer a division from one perpendicular edge of a rectangle to another (*opposite, centre and bottom*).

Some of geometry's simplest forms, the square, the double square and the hexagon, when given rational edges, have diagonals commonly seen as unresolvable in whole numbers (*below*). Known today as *irrational numbers*, for Egyptian and Pythagorean philosophers they were seen as volatile movements from one integer to another, living processes of gestation; *values*, rather than numbers.

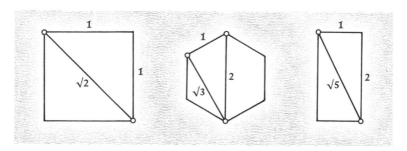

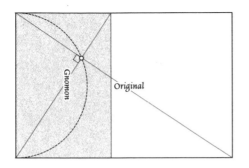

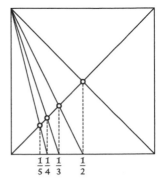

$$\frac{1}{5} \quad \frac{1}{4} \quad \frac{1}{3} \qquad \frac{1}{2}$$

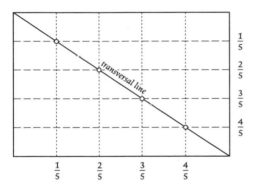

$$\frac{1}{5} \quad \frac{2}{5} \quad \frac{3}{5} \quad \frac{4}{5}$$

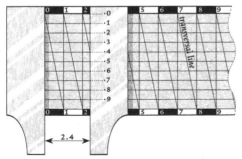

ABOVE LEFT: The gnomon of a rectangle (shaded), is defined by a perpendicular intersecting the diagonal from a third corner, after drawing a semicircle from the centre of the rectangle's short edge.

ABOVE RIGHT: Harmonic division growing from a square's diagonals

LEFT: A transversal line transfers divisions of a rectangle from one perpendicular edge to another.

LEFT: Transversals were once used on measuring instruments such as this caliper, allowing graduations to be read at finer degrees of accuracy. Astronomer Tycho Brahe [1546–1601], used this method to make the most accurate instruments of his age.

FACING PAGE: The relationships between the edges and diagonals of the square ($\sqrt{2}$), hexagon ($\sqrt{3}$) and double square ($\sqrt{5}$), are unresolvable in whole numbers.

THE DIAGRAM
harmonic geometry

The Platonic philosopher Boethius [477–524 AD] describes in his *Geometria* a '*diagramma*' used by the Pythagoreans in which '*number and tone ratios were represented with strokes and geometric operations*'. This is our Diagram—the marriage of geometry and harmony.

To form the Diagram in a square, simply draw the eight semi-diagonals (i.e. the diagonals of the interior double squares). As these semi-diagonals cross each other, a host of rational divisions appear. The semi-diagonals are in a 1:$\sqrt{5}$ proportion to half the square's edge, and can also be thought of as the action of phi in the form of the square root of 5 giving birth to whole numbers in geometric form.

The miraculous properties of the Diagram are scattered through the history of art and architecture. Hans Kayser [1891–1964] was perhaps the first to spot it, in the tone number relationships of the *Pythagorean division table (see page 18)* and the diagrams of the medieval goldsmiths of Basel, naming it the '*Harmonic Division Canon*'. Malcolm Stewart called it the '*Starcut*', finding it in Vedic architecture, the weaving of tartans and the sword-fighting manuals of medieval Spain *(see page vi)*.

Remarkably, the Diagram's dividing principle works in any rectangle or rhomb, and even in any triangle *(below)*.

 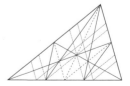

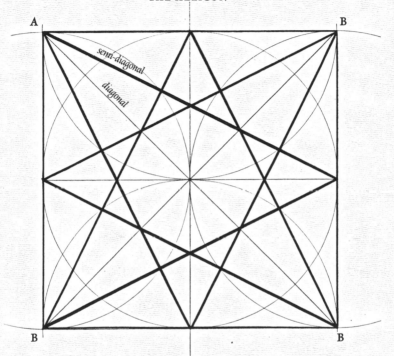

A B

semi-diagonal

diagonal

B B

FACING PAGE: *The rational dividing properties of the Diagram are not limited to squares. The device can be drawn in any rectangle or rhomb. Triangles can be treated by finding the midpoints of each edge, and then drawing half a Diagram.*

ABOVE: THE DIAGRAM *is formed by drawing the eight semi-diagonals of a square. This squashed star has remarkable rational dividing properties, as well as a host of other qualities that have been used by designers for over 7000 years.*

9

THE 3-4-5 TRIANGLE
building block of the universe

The 3-4-5 triangle, which Plato called '*the building block of the universe*', has each side rational, arrested and finite. It is found in early megalithic structures (*see page 55*), and in ancient Egypt, in the King's Chamber of the Great Pyramid and the dimensions of Menkaure's pyramid (*below*), thousands of years before Pythagoras seeded it in mathematics.

The semi-diagonals that compose the Diagram delineate this triangle at many different scales, the largest overlap creating a square which perfectly contains the triangle's incircle of radius 1 and diameter 2 (*see opposite*). Eminently practical, the 3-4-5 triangle (area 6) has been used by builders for thousands of years to verify right angles.

Plutarch talks of the 3-4-5 triangle in his account of the myth of Isis and Osiris, saying that '*The Egyptians hold in high honour the most beautiful of the triangles, since they liken the nature of the Universe most closely to it*'. He compares the sides to the mythical figures of the story: Osiris to the side of 3, as '*Cause*'; Isis to the side of 4, as the '*Place of Generation*'; and Horus to the hypotenuse of 5, as '*The World*' or '*The Perceptible*'; giving us hints of its philosophical heritage.

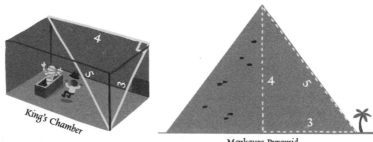

King's Chamber

Menkaure Pyramid

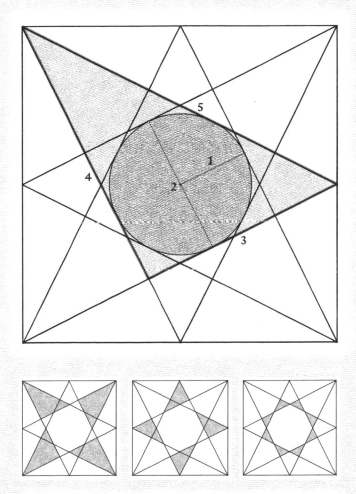

ABOVE: *The Diagram is composed of 3-4-5 triangles repeated at different scales.*

HALVES & QUARTERS
octave shifts

The geometry of circles, rectangles and polygons is inseparable from the principle of halving and doubling. Every circle or polygon is halved by its centre; every rectangle is halved by its diagonals.

The same is true in music. Take any string tuned to a note; doubling the string's length gives the same note one octave lower; halving it gives the note one octave higher. Adding $\frac{1}{2}$ to 1 gives $\frac{3}{2}$, a musical fifth. In ancient Egypt this principle was governed by Thoth, bringer of the arts. The saying of Thoth found in the coffin of Petamun embodies this doubling principle (*see acknowledgements page*).

The Diagram shown opposite displays the natural halving principle. The large white dots indicate where two semi-diagonals cross to divide the edges in half, and then into quarters. The smaller dots show how the quarters are guided by the square's original construction arcs.

Below, the halving principle is continued to find the 8ths (*right*), and 16ths (*left*).

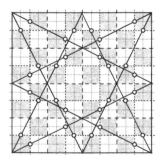

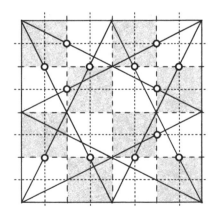

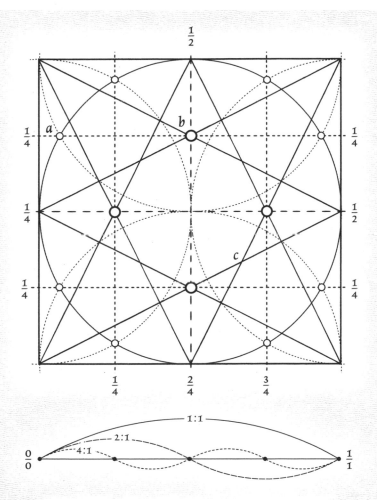

TOP: The Diagram's innate half and quarter nodes (large white dots).
BOTTOM: dividing a string by halves and quarters gives ascending octaves.

THIRDS & SIXTHS
and twelfths too

Dividing a line into three using compasses is difficult to achieve with accuracy, but the Diagram has nodes for third divisions already in place (*opposite, the nodes of the thirds marked by large white dots*). Indeed, the ease with which the Diagram creates this division in any rectangle may be the reason the 'rule of thirds' became so popular in painting and architectural composition.

The Diagram here shows how harmonic proportion governs its nodes: $\frac{1}{3}$ is the harmonic mean between $\frac{1}{2}$ and $\frac{1}{4}$, and $\frac{2}{3}$ is the harmonic mean between 1 and $\frac{1}{2}$ (*see p.36*). A string increased by a third gives $\frac{4}{3}$, a musical fourth, the poignant sibling to the cheerful musical fifth.

Verticals and horizontals drawn through the third nodes intersect the semi-diagonals of the Diagram to give every sixth division (small white dots opposite).

The technique can then be repeated, as the verticals and horizontals through the sixth nodes again cut the Diagram to immediately give every twelfth division (*right, white dots*). And the process can be continued again and again, to give smaller and smaller divisions, each half of the previous interval.

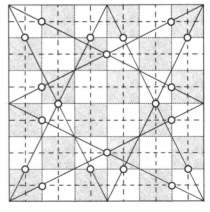

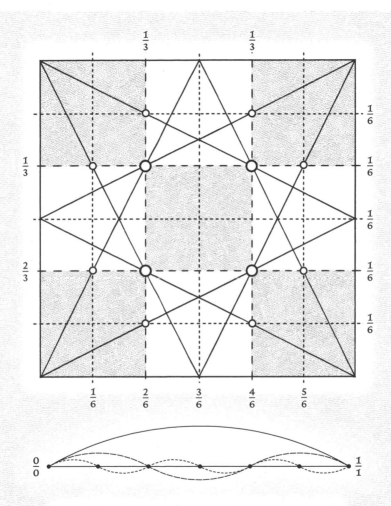

ABOVE: *The Diagram naturally divides itself into thirds and then sixths.*

FIFTHS
and tenths

The fifth division is the final fraction that is provided free by the Diagram without the need to add extra lines. The crossing points closest to each edge align to give perfect fifths along each edge. Simply join with lines for a 5×5 grid (*opposite, white dots*).

Once again, these divisions can be halved. The lines of the 5×5 grid cross the lines of the Diagram's semi-diagonals to produce new nodes which can be used to divide the edges into tenths (*shown below*). And this halving property can again be continued indefinitely, to produce divisions of twentieths, fortieths and so on.

Again the nodes on which we find our fifths define the harmonic means between nodes on either side. Between $\frac{1}{3}$ and $\frac{1}{2}$ the harmonic mean is $\frac{2}{5}$; between $\frac{1}{2}$ and $\frac{3}{4}$ the harmonic mean is $\frac{3}{5}$; and between $\frac{2}{3}$ and 1 the harmonic mean is $\frac{4}{5}$.

In the Pythagorean tuning system, all harmonies are based on multiples of 2 and 3 (known as 3-limit tuning). The inclusion of multiples of 5 in the harmonies is known as Just intonation (or 5-limit tuning). It expands the range of possible tones available by creating intervals such as 5:4, 6:5, 10:9 and 25:24.

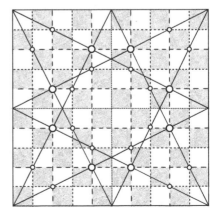

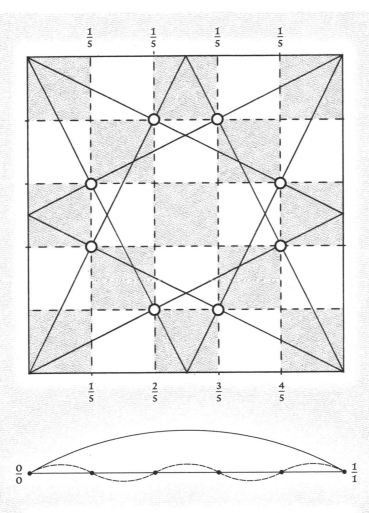

$$\frac{1}{5} \quad \frac{1}{5} \quad \frac{1}{5} \quad \frac{1}{5}$$

$$\frac{1}{5} \quad \frac{2}{5} \quad \frac{3}{5} \quad \frac{4}{5}$$

$$\frac{0}{0} \qquad \frac{1}{1}$$

ABOVE: *Dividing into fifths. Lines drawn through the white dots make a 5×5 grid.*

PYTHAGOREAN TABLES
number, music, geometry

The Pythagorean division table (*shown opposite*) is the partner of the multiplication table familiar to all school children (still called the Pythagorean table in Italy). Whereas the multiplication table shows all combinations of integers multiplied, the division table shows all combinations of integers divided. Discovered by Albert von Thimus [1806–1878] in a commentary by Iamblichus [245–325 AD] and later developed by Hans Kayser, it is the numerical equivalent of the Diagram.

Each number on the diagonal from top left to bottom right is unity (in the multiplication table they are squares). All numbers above the diagonal are reciprocal to those below. Numbers in a vertical line show a sequence of arithmetic means. Numbers in a horizontal line show a sequence of harmonic means. To divide the right edge by any interval, project a line from the origin 0/0 through the desired interval to divide the right edge of the square. This method is used to position bridges on the monochord (*below*), also known as the canon (*Greek, 'law'*).

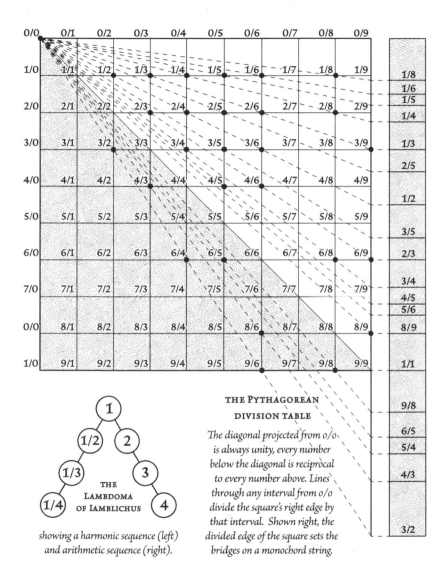

0/0	0/1	0/2	0/3	0/4	0/5	0/6	0/7	0/8	0/9
1/0	1/1	1/2	1/3	1/4	1/5	1/6	1/7	1/8	1/9
2/0	2/1	2/2	2/3	2/4	2/5	2/6	2/7	2/8	2/9
3/0	3/1	3/2	3/3	3/4	3/5	3/6	3/7	3/8	3/9
4/0	4/1	4/2	4/3	4/4	4/5	4/6	4/7	4/8	4/9
5/0	5/1	5/2	5/3	5/4	5/5	5/6	5/7	5/8	5/9
6/0	6/1	6/2	6/3	6/4	6/5	6/6	6/7	6/8	6/9
7/0	7/1	7/2	7/3	7/4	7/5	7/6	7/7	7/8	7/9
0/0	8/1	8/2	8/3	8/4	8/5	8/6	8/7	8/8	8/9
1/0	9/1	9/2	9/3	9/4	9/5	9/6	9/7	9/8	9/9

Right edge divisions (top to bottom): 1/8, 1/6, 1/5, 1/4, 1/3, 2/5, 1/2, 3/5, 2/3, 3/4, 4/5, 5/6, 8/9, 1/1, 9/8, 6/5, 5/4, 4/3, 3/2

THE LAMBDOMA OF IAMBLICHUS

1
1/2 2
1/3 3
1/4 4

showing a harmonic sequence (left)
and arithmetic sequence (right).

THE PYTHAGOREAN
DIVISION TABLE

*The diagonal projected from 0/0
is always unity, every number
below the diagonal is reciprocal
to every number above. Lines
through any interval from 0/0
divide the square's right edge by
that interval. Shown right, the
divided edge of the square sets the
bridges on a monochord string.*

SEVENTHS
and ninths

To divide a rectangle's edge into seven, draw lines through the fifth and third nodes of the Diagram (*as shown opposite, top*). Alternatively, the sevenths can be found by drawing lines from the quarter points on the edges to the facing half points, and marking the places these cross the semi-diagonals (*opposite bottom left*). Another method is to divide the square's edges into fifths, and draw diagonals from each fifth to the next fifth on the opposite edge, finding the sevenths where these cross the semi-diagonals (*opposite bottom right*). Western music does not divide strings into seven or use multiples of seven in its harmonies (7-limit tuning), although they are used in Arabic muqams.

Dividing into ninths again uses the quarters to halves diagonals, selecting the second crossing point, or the fifths to fifths diagonals, selecting the first crossing point (*below left and right*).

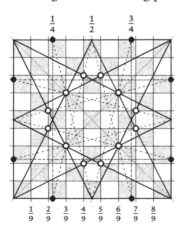

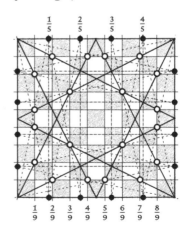

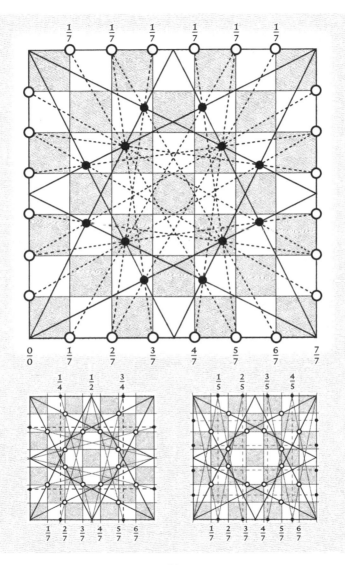

ELEVENTHS

earth, moon and pi

The Diagram divides itself into eleven very elegantly, using the nodes for the fifths and the facing half nodes (*as shown below*). Intervals based on elevenths (or 11-limit tuning) tend not to appear in music, compositions by Pythagorean theorist and musical instrument maker Harry Partch [1901–1974] being the notable exception.

The drawing opposite, after an original by John Michell, shows the remarkable connection between the relative diameters of the Earth (size 11) and the Moon (size 3) joined by 3-4-5 triangles (*one shown*). The construction also solves the ancient puzzle of how to draw a square and circle with the same perimeter, and demonstrates how the Great Pyramid of Giza, with its edge-to-height ratio of 11:7 (440 × 280 Royal Egyptian cubits), similarly unites the square and the circle.

Using the reciprocal properties of perpendicular edges (*p.33*) a length of $\frac{11}{7}$ is simple to draw. Since the square's edge is 1, a line projected from the bottom corner of the square through the $\frac{7}{11}$ point (where the Moon and Earth squares touch) can be extended as shown until it makes a triangle defining a height of $\frac{11}{7}$.

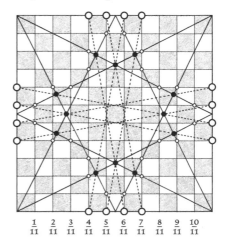

$$\frac{1}{11} \quad \frac{2}{11} \quad \frac{3}{11} \quad \frac{4}{11} \quad \frac{5}{11} \quad \frac{6}{11} \quad \frac{7}{11} \quad \frac{8}{11} \quad \frac{9}{11} \quad \frac{10}{11}$$

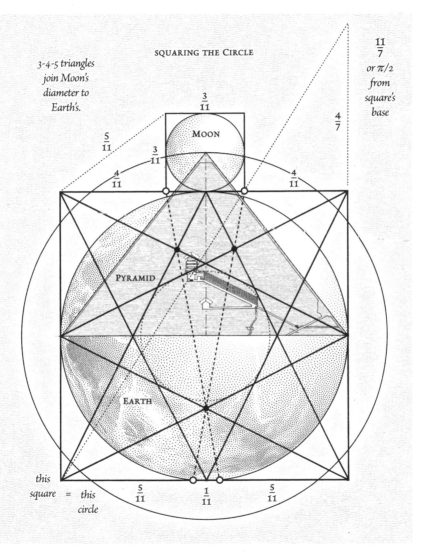

3-4-5 triangles
join Moon's
diameter to
Earth's.

$\frac{11}{7}$
or $\pi/2$
from
square's
base

$\frac{3}{11}$

$\frac{4}{7}$

MOON

$\frac{5}{11}$

$\frac{3}{11}$

$\frac{4}{11}$

$\frac{4}{11}$

PYRAMID

EARTH

this
square = this
circle

$\frac{5}{11}$

$\frac{1}{11}$

$\frac{5}{11}$

23

THIRTEENTHS AND ON
why it all works

Any fraction can be found in the Diagram. For example, one technique for finding thirteenths is shown (*opposite top left*), and another for finding seventeenths (*opposite top right*). But why does it work?

The halving and doubling action rely on the principle that similar rectangles share diagonals (*shown below*). Any line drawn parallel to the Diagram's edge crosses six semi-diagonals, with each crossing defining the short or long edge of a small double square which intersects the lines of the Diagram to halve and halve again indefinitely (*opposite, bottom*).

We have already seen how the thirds, quarters and fifths are the result of two diagonals crossing, and how these can then be halved again and again. All other fractions can then be found by crossing diagonals from the nodes for earlier fractions, as we saw with elevenths, thirteenths and seventeenths. This is a form of Farey fraction addition (*see page 52*).

To find other fractions with the Diagram, use the harmonic mean of the semi-diagonal, i.e. $\frac{1}{2}$, and the point where a second diagonal (made by joining other intervals) cuts the square's edge. For instance the harmonic mean of $\frac{1}{2}$ and $\frac{4}{5}$ is $\frac{8}{13}$, or of $\frac{1}{2}$ and $\frac{5}{7}$ is $\frac{10}{17}$.

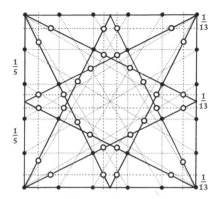

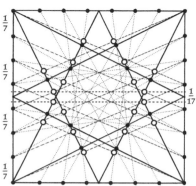

ABOVE: *Thirteenth divisions (white dots)
found by 5:3 diagonals drawn from fifth
divisions of the square's edge (black dots) to
where they intersect the Diagram.*

ABOVE: *Seventeenth divisions (white dots)
found by 4:7 diagonals drawn from seventh
divisions (black dots) of the square's edge to
where they cross the Diagram.*

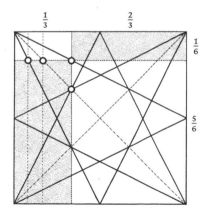

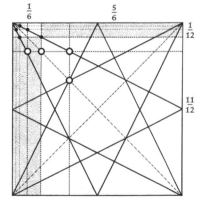

ABOVE: *The natural halving quality of the
Diagram: a line dividing the square at any
interval (shown above using thirds) hits a
semi-diagonal at half that interval.*

ABOVE: *Continuing the halving process: a
line through the newly halved interval hits
another semi-diagonal, halving it again.
This can be continued indefinitely.*

THE HELICON
mountain of the muses

The Pythagorean musical instrument known as the *helicon* is named for Mount Helicon, the 'Seat of Inspiration', where, according to Hesiod, the Muses '*make their fair, lovely dances*' (*see frontispiece*). Its form describes the Diagram, with strings located on half and third nodes, and a pivoting bridge providing the semi-diagonal (*opposite top*). This ancient instrument can be accurately retuned to any key simply by moving the pivoting bridge, a quality very few instruments possess.

The great astronomer Ptolemy [100–c.170 AD] wrote a short book on harmonics in which he describes this instrument and offers a modified version with eight rather than four strings (*shown below, and opposite bottom*). Ptolemy goes on to compare the action of harmonic intervals and tones to legal and judicial operations, the division of the zodiac and the swings in temperament within the human soul.

The Diagram is thus deeply rooted in ancient ideas of imagination, inspiration and music as well as geometry.

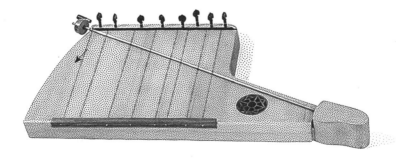

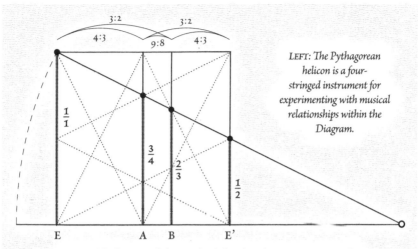

LEFT: The Pythagorean helicon is a four-stringed instrument for experimenting with musical relationships within the Diagram.

ABOVE: The four string helicon is clearly based on the same geometry as the Diagram with string lengths and positions determined by the Diagram's nodes, and the pivoting bridge sharing one of the Diagram's semi-diagonals.

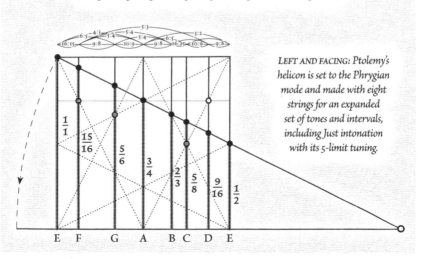

LEFT AND FACING: Ptolemy's helicon is set to the Phrygian mode and made with eight strings for an expanded set of tones and intervals, including Just intonation with its 5-limit tuning.

THE GOLDEN SECTION
the creative moment

The circle that sits inside the overlapping 3-4-5 triangles (*page 11*) sets up a series of golden section relationships (*opposite top left*). This circle is 1:phi in relation to any of the four smaller circles around it.

Two more circles can be drawn that overlap to divide each circumference into five (*opposite top right*). The Osirion at Abydos, one of the most ancient and puzzling buildings in Egypt, uses this same construction (*analysis below after Lucie Lamy*).

Dividing a square's edge into 1:φ proportions from each corner creates a golden version of the Diagram (*opposite, bottom*).

The creative moment of phi sits as seed or cause in both Reality and the Diagram, giving birth to all rational divisions.

ABOVE: The circle sitting inside the 3-4-5 triangles is 1:phi to any of the four smaller circles, and 1:√5 to the enclosing circle.

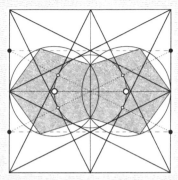

ABOVE: Two circles, drawn from the edges of the inner circle to the square's edge, overlap to divide their circumferences into five.

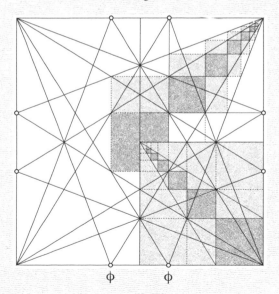

LEFT: The Golden Diagram. This golden section grid divides and subdivides like the Diagram, but with nodes only falling on golden section points. First cut each edge of the square in two places, 1:φ from each corner, then join these points using diagonals to each of the corners, as with the Diagram. This creates an expanding and diminishing grid replete with golden section proportions.

φ φ

ROOT RECTANGLES
secrets of ancient surveyors

Perhaps the most curious property of the Diagram is its relationship to the circle contained within its square. Where the Diagram intersects this circle's circumference, nodes appear that allow the construction of rectangles of whole number proportions. These double squares (*opposite, top left*), triple squares (*opposite, top right*) and septuple squares (*opposite, bottom left*) all have diagonals of the same length, equal to the square's edge, or the circle's diameter (*opposite, bottom right*).

By joining the quarter nodes on the edges of the square through the Diagram's centre, the rectangles now align with each other, enabling a Maltese cross to be drawn (*below*). Malta is home to some of the earliest megalithic sites in Europe, and similar grids of harmonically proportioned rectangles also appear in the arrangement of megaliths at Carnac, in Brittany (*see page 54*).

The grid of double, triple and septuple squares creates a series of phi ratios (φ:1:Φ, or 0.618:1:1.618, *shown right*). This grid then repeats at a scale of 1:√5 inside the inner circle (*only the triple squares are visible in the diagram*), making the Diagram a self-similar fractal system.

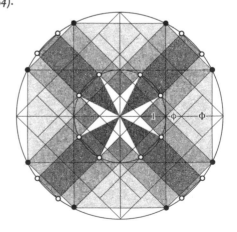

30

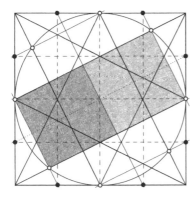

ABOVE: *Double squares, made from the intersection of the Diagram and its contained circle. The double squares are chiral, i.e. are left- (shown) or right-oriented.*

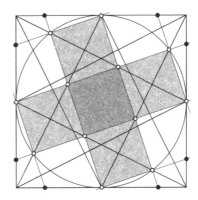

ABOVE: *Triple squares, drawn from different points where the circle cuts the Diagram. Again left- (shown) or right-oriented. The central square tangents the semi-diagonals.*

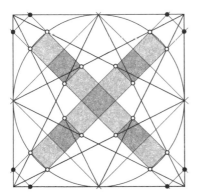

ABOVE: *Septuple squares, oriented to the corners of the Diagram where it cuts the circle. Another square fits outside the circle perfectly touching the square's edges.*

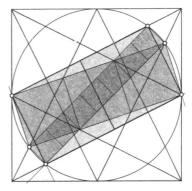

ABOVE: *Double, triple and septuple squares, with the same length diagonals, equal to the diameter of the contained circle, or the edge length of the Diagram.*

RECIPROCITY
continuous proportional relationships

Reciprocity is the mirror-like bond of inverse qualities. We find it everywhere: plant roots delve down and their branches reach up; our inner states meet outer events; justice, social responsibilities and relationships are reciprocal when in balance; even the common handshake shows this bond of inverses brought together as one.

In mathematics, division is the reciprocal of multiplication. A reciprocal pair multiplied together reconstitute unity, thus the geometric mean of any reciprocal pair is always 1 (*shown below*).

Reciprocals can easily be drawn using the Diagram. Simply project a line from one corner of the square through the required fraction on the opposite edge. Continue this line until it meets the extended edge of the square to give the reciprocal of the fraction (*shown opposite, top*).

Projection of a geometric sequence is made simple by reciprocal ratios. In the example (*opposite*), a square of size $\frac{1}{4}$ is drawn in one corner of the Diagram, and lines connected from this square's corners back to the Diagram's opposite corner. Extending the square's edges out to these lines gives a sequence of squares that contract or expand by a factor of $1 - \frac{1}{4} = \frac{3}{4}$, or its reciprocal $\frac{4}{3}$ as shown.

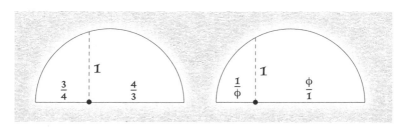

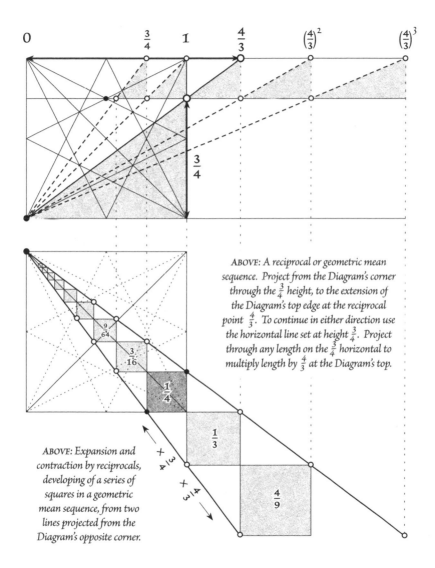

Labels in upper diagram:
0 $\frac{3}{4}$ 1 $\frac{4}{3}$ $\left(\frac{4}{3}\right)^2$ $\left(\frac{4}{3}\right)^3$

$\frac{3}{4}$

ABOVE: A reciprocal or geometric mean sequence. Project from the Diagram's corner through the $\frac{3}{4}$ height, to the extension of the Diagram's top edge at the reciprocal point $\frac{4}{3}$. To continue in either direction use the horizontal line set at height $\frac{3}{4}$. Project through any length on the $\frac{3}{4}$ horizontal to multiply length by $\frac{4}{3}$ at the Diagram's top.

ABOVE: Expansion and contraction by reciprocals, developing of a series of squares in a geometric mean sequence, from two lines projected from the Diagram's opposite corner.

$\frac{9}{64}$ $\frac{3}{16}$ $\frac{1}{4}$ $\frac{1}{3}$ $\frac{4}{9}$

$\times \frac{3}{4}$

$\times \frac{4}{3}$

33

THE GEOMETRIC MEAN
practical perpendiculars

The Renaissance architect Leon Battista Alberti [1404–1472] states in his *Ten Books on Architecture* that *'The geometric mean is very difficult to find by numbers, but it is very clear by lines'*. He is describing the geometric mean's quality of being revealed by intersecting a rectangle's diagonal with a perpendicular from a third corner (*opposite top and bottom*).

This perpendicular reveals some remarkable things, first noted by Jay Hambidge [1867–1924]. In particular, a series of gnomons (rectangles with identical proportions) can be drawn, where the diagonal and its perpendicular intersect, and again by continuing the perpendicular to the rectangle's edge. A useful trick for designers and geometers.

This method of geometrically deriving the geometric mean illustrates the nesting principle of all polygons. In any three nested polygons, the middle polygon's perimeter, or edge length, will always be the geometric mean of the outer and inner (*shown below*)

We see why Plato insists the geometric mean binds bodies together. Flowers use nested polygons to build their blooms and DNA in cross section is arranged from nested decagons that unravel to build us!

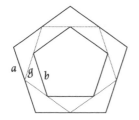
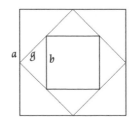
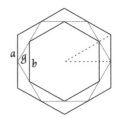

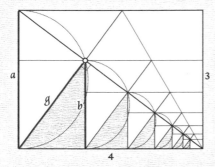

ABOVE: *Geometric mean (g) of a and b where a 4:3 rectangle's diagonal and perpendicular meet.*

ABOVE: *Santa Maria Novella, Florence, by Palladio, uses gnomons to proportion.*

RIGHT: *Gnomons of a rectangle, made by perpendiculars to its diagonal, also define the geometric mean g between edge length a and gnomon edge length b.*

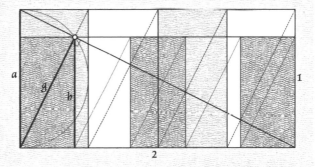

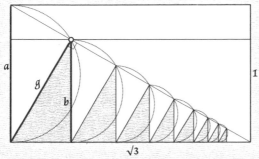

LEFT: *Perpendiculars to the diagonal of a 1:√3 rectangle create a series of diminishing triangles. The line joining any two parallels is always their geometric mean. This drawing is one twelfth of a hexagon with a series of nested hexagons inside (facing page, right).*

THE HARMONIC MEAN
backwards and inside

Archytas was the first to name the 'harmonic' mean. The earlier Pythagorean term was 'subcontrary', meaning backwards and inside, referring to the triangles in the geometric construction by Pappus of Alexandria [c. 290–c.350 AD] which unites all three means (*opposite*).

The harmonic and arithmetic means are intimately connected. The product of any two extremes a (smaller) and b (larger) is equal to the product of their arithmetic and harmonic means (*this and other relationships shown below and opposite*). In the Diagram, the diagonals and semi-diagonals cross to give the thirds, as the harmonic mean of 1 and $\frac{1}{2}$ is $\frac{2}{3}$, so the harmonic mean can be understood as the point where diagonals cross. The same is true for any interval. Can Plato's '*harmonic motions of the soul*' likewise be understood in terms of this crossing function?

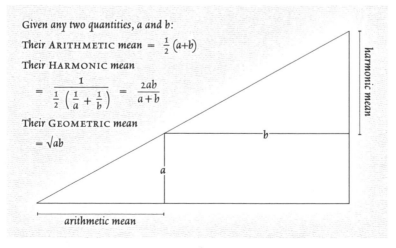

Given any two quantities, a and b:

Their ARITHMETIC mean $= \frac{1}{2}(a+b)$

Their HARMONIC mean

$$= \frac{1}{\frac{1}{2}\left(\frac{1}{a}+\frac{1}{b}\right)} = \frac{2ab}{a+b}$$

Their GEOMETRIC mean

$$= \sqrt{ab}$$

harmonic mean

b

a

arithmetic mean

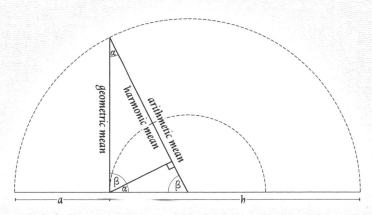

ABOVE: *The three Pythagorean means. A circle diameter a+b has a radius equal to the arithmetic mean of a and b. A perpendicular drawn to the circumference where a and b meet is the geometric mean. The harmonic mean is then found as shown.*

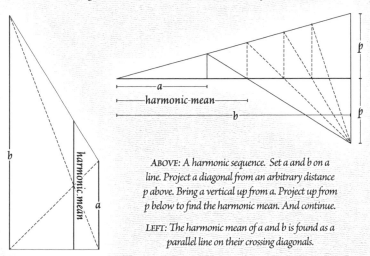

ABOVE: *A harmonic sequence. Set a and b on a line. Project a diagonal from an arbitrary distance p above. Bring a vertical up from a. Project up from p below to find the harmonic mean. And continue.*

LEFT: *The harmonic mean of a and b is found as a parallel line on their crossing diagonals.*

THE HUMAN CANON
anthropocosmos

The human form as an image of the Cosmos is a consistent theme amongst early societies. The same fractional divisions and harmonic ratios found in the Diagram were used by the ancient artists to proportion the various parts of their figures (*opposite top*).

Analyses of the ancient Egyptian canon by R. A. Schwaller de Lubicz [1887–1961] indicate a use of continued harmonic division to create key points on the form. The image (*below*) of an Egyptian Neter ('principle' or 'nature') shows ratios mirroring, or reciprocal to, the human figure. Note the headdress has a 3:11 Moon:Earth ratio to the Neter's height. Another example is shown (*opposite, bottom*).

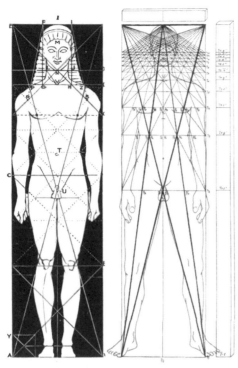

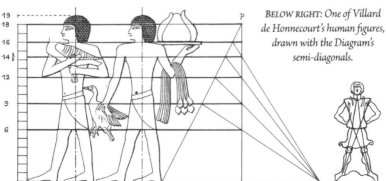

FAR LEFT: Jay Hambidge's analysis of the ancient Greek human canon. Two partial Diagrams meet at the genitals defining key points of the figure known as a 'kouros'.

LEFT: Hans Kayser's analysis of the human figure using the Diagram, with Villard de Honnecourt's human canon shown by darker lines. All key points of the body and face conform to harmonic divisions, although the hands are overlarge.

FACING PAGE: Image of an Egyptian Neter by R.A. Schwaller de Lubicz.

BELOW LEFT: Schwaller's drawings of the ancient Egyptian human canon, showing the of use harmonic division to proportion all the parts.

BELOW RIGHT: One of Villard de Honnecourt's human figures, drawn with the Diagram's semi-diagonals.

THE VILLARD CANON
harmonic page division

The artist Villard de Honnecourt [1200–1250] was one of the few medieval designers to leave any clues to the methods of Gothic architecture. His notebook contains drawings of many geometric devices used by the masons to create the grand cathedrals of the Middle Ages, and amongst these is a method for creating proportional borders for manuscript pages, based on the Diagram.

Popularised in the twentieth century by typographers Raul Rosarivo [1903–1966] and Jan Tschichold [1902–1974], a friend of Hans Kayser, Villard's method ingeniously uses diagonals and semi-diagonals to create diminishing rectangles of the same proportions, that are offset on the page to give wider outer and lower margins.

This practical device can save designers hours of tedious calculation whatever the century. For example, using this method on a 4:3 double page (*opposite top*) creates a text block that is the same height as the page width, with the top margin half the width of bottom, and the inner margin half the width of the outer.

 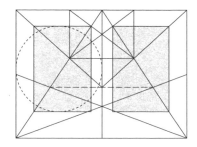

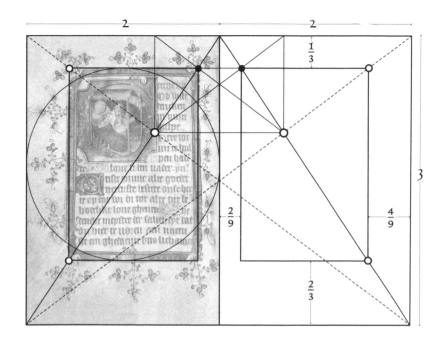

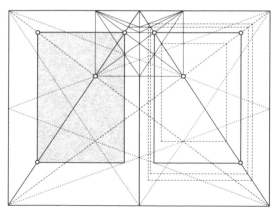

ABOVE & LEFT: *The Villard Canon creates a text block equal in height to the page's width. The text block is offset by its top corners intersecting the diagonal and semi-diagonal of the page, giving inner:outer and top:bottom borders with 1:2 width proportions.*

OPPOSITE: *Other page ratios from the Villard Canon.*

HARMONIC DESIGN
ratio and proportion

Harmonic proportions are ubiquitous in traditional design. The simple relationships found in music can be used to create unified compositions that bring disparate elements together.

> *We shall therefore borrow all our Rules for the Finishing of our Proportions, from the Musicians, who are the greatest Masters of this Sort of Numbers, and from those Things wherein Nature shows herself most excellent and compleat.*
>
> <div align="right">Leon Battista Alberti, De Re Aedificatoria, c.1450.</div>

In their beautiful book *By Hand and Eye*, George Walker and Jim Tolpin illuminate this process. The dominant part of the form is given a whole number of units, with secondary aspects being given a lesser whole number, and further subdivisions and details then added using fractions of the original unit (*below, and opposite bottom*).

Neoclassical architecture and design from the mid-eighteenth century onwards was particularly enamoured by this method, learning from ancient Greek architecture and Renaissance writings (*opposite top*).

Such an effective and efficient use of harmonic thinking frees the designer's creativity in any of the arts, from painting and pottery, to jewellery and carpentry, to architecture and city planning.

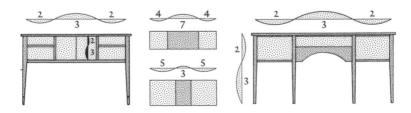

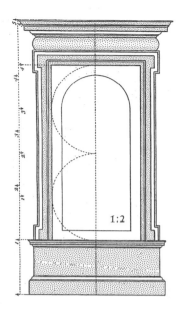

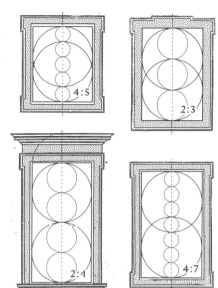

ABOVE: *Fractionally divided moundings surrounding a 1:2 window, from James Gibbs'* Rules for Drawing the Several Parts of Architecture, *1753.*

ABOVE: *Further harmonic proportions from Gibbs. This method is simple to adapt to any conditions and materials, and is easy for craftsmen to fabricate using dividers or the Diagram.*

LEFT & BELOW: *Simple musical ratios can be used to relate major and minor parts as well as small details of a cabinet design. From Walker & Tolpin.*

BELOW: *Drawing by George Walker and Jim Tolpin showing how fractional divisions of edge length can be used to determine different frame widths and create a harmonious unity in the design.*

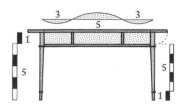

CLASSICAL ORDERS
tonal vocabulary of greek architecture

In ancient Greece, the fractional thinking exemplified by the Diagram was used throughout society, from settling legal claims to the toning of vowels in speech. The classical orders of ancient Greek architecture demonstrate a complete system of ratio and proportion and a sophisticated knowledge of geometry and harmonics.

The most common unit in this system is the width of a column at its base, multiplied and reduced by simple fractions to create some of humanity's most enduring architectural forms (*below and opposite top*).

The Roman architect Vitruvius [80–15 BC] was of the opinion that

> *Music, also, the architect ought to understand so that he may have knowledge of the canonical and mathematical theory.* Marcus Vitruvius Pollo, De Architectura, c.1450

The base unit of a fractional system, through this method, develops its length into a full set of related intervals, allowing the parts of the design to sing in harmonic tone-lengths. This same system is found, with varying fractions, in proportional architecture from Egypt to India.

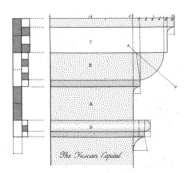

The Tuscan Capital

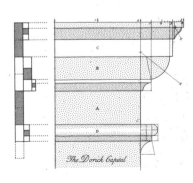

The Doric Capital

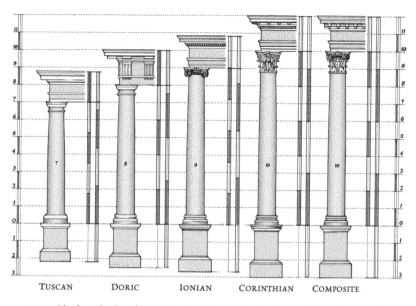

TUSCAN	DORIC	IONIAN	CORINTHIAN	COMPOSITE

ABOVE: *The classical orders of ancient Greek architecture. Each order uses different fractions of the column's base width to set the column height (numbers within the columns). This height is then divided by different fractions to find heights for the pedestal and entablature and set moulding details.*

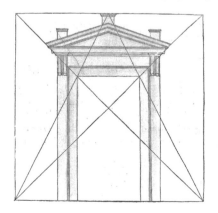

LEFT: *Door and Portico from proportions by Vitruvius, using a partial Diagram to set the door width, mouldings and other details.*

OPPOSITE: *Complex mouldings from the tops of Tuscan and Doric columns, developed by dividing the original column width by repeated harmonic intervals. This highly innovative method is how all Classical and Neoclassical architecture was adorned with a unified scheme of number, geometry and harmony.*

45

HARMONIC ART
from Inca astronomers to renaissance painters

As a composition aid for painters and architects, the Diagram efficiently ties together disparate elements of a design. The painting opposite shows Luca Pacioli [1447–1517], friend of Leonardo da Vinci [1452–1519], passing the geometric tradition to Albrecht Dürer [1471–1528]. The Diagram is used in a 6:5 rectangle to set up the perspective vanishing point, frame the figure of Pacioli and unify other elements.

It is no surprise to find the presence of the Diagram in Egypt (*top left*), or in a drawing of a classical facade by Andrea Palladio [1508–1580] with the roof angle determined by the semi-diagonal (*below*), but to discover it in an Inca sunstone (*top right*) surely reveals a global use.

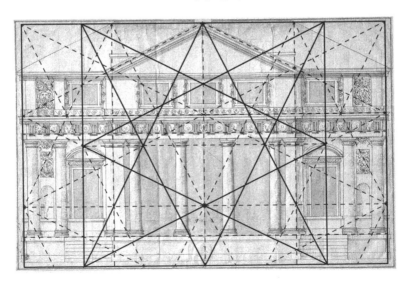

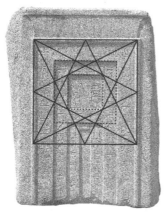

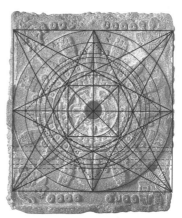

Tomb of Vizier Ustr, Karnak 1458 BC

Inca sunstone radii set by the Diagram

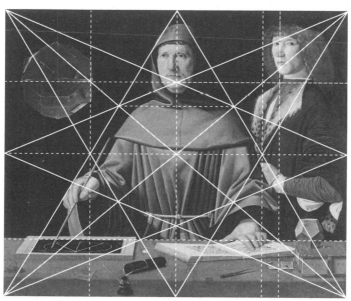

The Diagram used in Jacopo de' Barbari's painting of Luca Pacioli and Albrecht Dürer.

PERSPECTIVE
a harmonic system

Perspective (from the Latin *perspicere*, to see through), is often thought of as a Renaissance invention, but Plato declaims it in his *Republic*, c.375 BC, as '*The art of conjuring and of deceiving by light and shadow*', and Proclus [412–485 AD] mentions it in his commentary on Euclid, calling it '*optics*', and in the same sentence calling the study of musical ratios '*canonics*'.

Lines projected from the vanishing points of a perspective setup, draw equally spaced objects as a diminishing harmonic series (*below, and opposite top*), very similar to the Diagram. Finding the centre of a rectangle in perspective is identical to finding the harmonic mean between the two sides (*page 37*). All objects we see are projected to our eyes, a picture plane sits between eye and object (*opposite, bottom*).

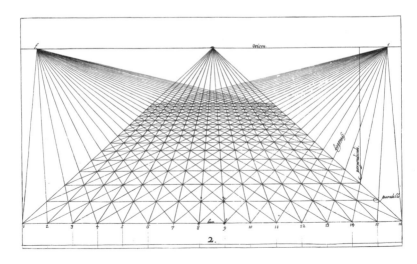

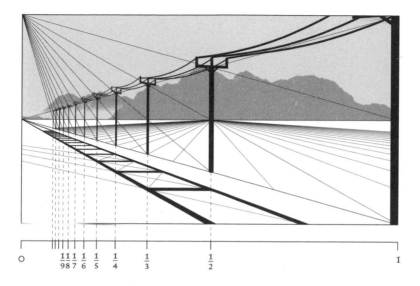

ABOVE: *A one-point perspective setup showing equally spaced objects diminishing according to a harmonic sequence, with each middle term the harmonic mean of terms either side. Perspective thus mimics sight in the same way as the harmonic division of a square (pages 7 and 53).*

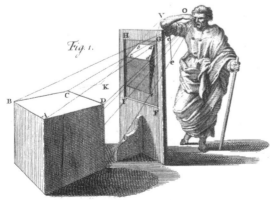

Fig. 1.

LEFT: *All objects we see project back to our eyes. The picture plane, shown in the illustration, is set between eye and object, and harnesses this projection to map points of the object to the canvas or page.*

FACING PAGE: *Drawing by architect Hans Vredeman de Vries [1527–1607] showing the harmonic sizing of equally spaced objects.*

PROJECTIVE GEOMETRY
harmonic nets

Projective geometry is the study of spatial relations free of measurement in which geometric figures are transformed by projection. Unlike Euclidian point-centred geometry, it develops from the plane, so points and lines are considered equal, able to generate each other, and infinite lines or planes can be drawn as parallels. Projective drawings easily generate conics and curves and define the shape of leaves, buds, pinecones, bodily organs and other natural forms.

Projective geometry reveals further secrets of the Diagram. The nine points and nine lines of the *Pappus Configuration* display close affinity to the structure of the Diagram (*opposite top right*). The harmonic or Mobius net (*opposite, bottom*) grows out of three points on a line. A harmonic sequence projects to an arithmetic sequence (*below, and opposite, centre right*), and a doubling geometric sequence projects to the same human canon intervals used in ancient Egypt (*opposite, centre left and page 39*).

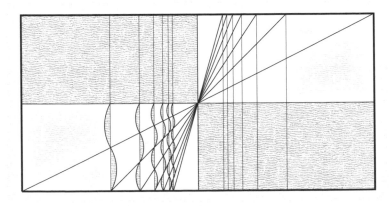

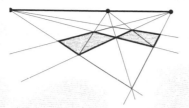

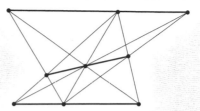

ABOVE: *Projective net of quadrangles in step measure grown from points on a line.*

ABOVE: *The Diagram-like Pappus Configuration, 9 lines each with 3 points.*

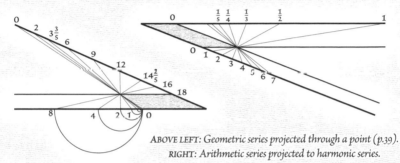

ABOVE LEFT: *Geometric series projected through a point (p.39).*
RIGHT: *Arithmetic series projected to harmonic series.*

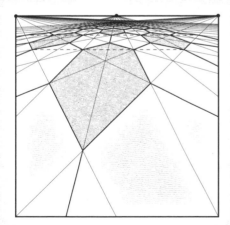

LEFT: *A harmonic net of hexagons, with its perspective-like forms, grown from just three points.*

FACING PAGE: *An arithmetic series projected to a harmonic series as in the diagram above. This version has lines 'sent to the infinite' i.e. parallels treated as infinite lines. The vertical arithmetic series projects to the horizontal harmonic series. This quality of projection through a fixed point makes reciprocal lengths (p.33) and the Farey diagram (p.53).*

THE FAREY DIAGRAM
harmonic division in mathematics

Certain properties of whole number fractions attributed to the geologist John Farey [1766–1826] have a bearing on the Diagram. The Farey diagram (*opposite top*) demonstrates these properties geometrically. Fractions are arranged in order of size, known as Farey Neighbours, starting with $\frac{0}{1}$ and $\frac{1}{1}$, then $\frac{1}{2}$, then $\frac{1}{3}$ and $\frac{2}{3}$, then $\frac{1}{4}$ and $\frac{3}{4}$, and continuing to infinity, each denominator adding a new set or 'order' of intervals correctly arranged by size. New middle terms can be calculated by adding the top numbers to give a new numerator, and adding the bottom numbers to find new denominator, e.g. $\frac{0}{1} + \frac{1}{3} = \frac{1}{4}$. This process of harmonic division, known as the *mediant function*, is exactly what happens in the Diagram. Hans Kayser's *Harmonic Division Canon* (*shown below*) is a version of the Diagram showing harmonic division on each edge, just like the Farey diagram.

Farey relationships can be mapped to tangenting circles, known as Ford circles (*opposite, bottom*), each with a diameter the square of the denominator of the fraction that it is centred on. Ford circles are a type of *Apollonian gasket*, named after Apollonius of Perga [c.240–c.190BC], who wrote a now lost text on tangenting circles.

The Farey sequence is as widespread in modern mathematics and physics as the Diagram is in ancient geometry.

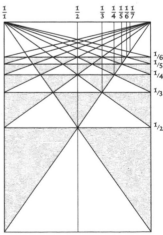

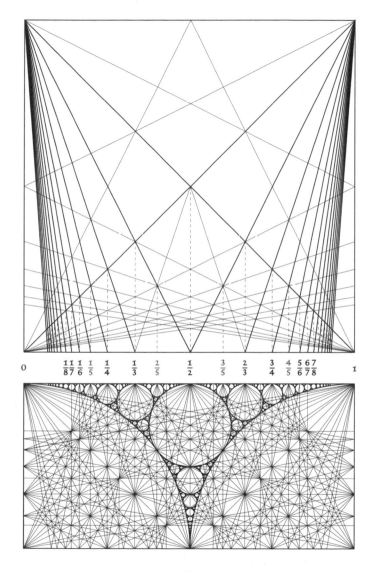

0 $\frac{1}{8}\frac{1}{7}\frac{1}{6}$ $\frac{1}{5}$ $\frac{1}{4}$ $\frac{1}{3}$ $\frac{2}{5}$ $\frac{1}{2}$ $\frac{3}{5}$ $\frac{2}{3}$ $\frac{3}{4}$ $\frac{4}{5}$ $\frac{5}{6}\frac{6}{7}\frac{7}{8}$ 1

ALIGNMENTS
enchanting the landscape

The ancients thought in proportion. We have seen a few examples permeating the arts from as early as ancient Egypt and Greece, but how far back does this method go? Exhaustive research by ancient metrologist John Neal has demonstrated the dissemination of integrated rational fractions and musical intervals in a measurement system spread across the globe at the very earliest phases of civilisation.

Similar discoveries by archaeologist Howard Crowhurst show the use of rational rectangles in many early sites, often assisting with the laying out of gigantic engineering projects, from megaliths to pyramids (*below and opposite*). For example, the megalithic site of Carnac in Brittany, parts of which are over 7000 years old, uses double squares, triple squares and 3-4-5 triangles to align thousands of stones. At Carnac's latitude the maximum and minimum rising and setting positions of the Sun and Moon are defined by these same geometries, inviting us to wonder whether its builders were binding geometry to the energies of the luminaries through the action of the means.

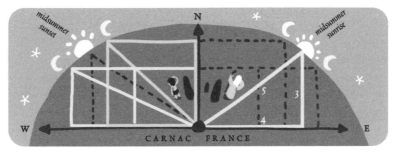

ABOVE: *At the latitude of Carnac, the diagonals of north-aligned squares and double squares define the max and min risings and settings of the Moon, while 3-4-5 triangles define the max and min rising and settings of the Sun. The megalithic Crucuno rectangle is a 3-4 rectangle, diagonal 5.*

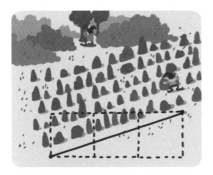

LEFT: *At Le Menec West in Carnac, rows of hundreds of megaliths are aligned to the angle of a triple square's diagonal, before changing direction to realign along the diagonal of a double square at Le Menec East. The use of the primordial geometries of squares, double squares, triple squares and 3-4-5 triangles clearly demonstrates their importance in the ancient megalithic canon of surveying and architecture.*

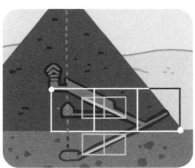

LEFT: *The angles of the passages ascending to the King's chamber and descending to the cave under the Great Pyramid of Giza are set by the diagonals of double squares.*

FACING PAGE, LEFT: *The diagonal of a double square aligns the entire Egyptian Temple of Luxor to midwinter sunrise.*

FACING PAGE, RIGHT: *The causeways of the Great Pyramid and Chephren's Pyramid are aligned to the diagonals of quadruple squares.*

Illustrations by Patrick-Yves Lachambre.

THE PRACTICE OF EVERYTHING
the glass bead game

Hans Kayser spent a lifetime researching harmonic phenomena, finding compelling evidence for harmony in the branching systems and perspective-like diminution in leaf size of plants (*below left and right*), the movement of water, the development of shells and in the geometries of crystal growth. All phenomena of nature and human creation can be transposed through rational numbers and their expression as harmonic and geometric forms, an idea the mystic George Gurdjieff [1866–1949] called 'the law of vibration'. Harmonics are even present in the energy states of atomic orbitals (*below centre*).

Herman von Helmholtz [1821–1894] described hearing as our most mathematical sense, as we are able to discern a wavelength to $\frac{1}{200}$mm, with the eye only able to see about $\frac{1}{24}$mm.

Balance and hearing are intimately woven, the centre of the ear is on the balance line of the body, and its fluid keeps us level. Vision and hearing are reciprocal. Eyes see equally spaced objects as harmonic, ears hear harmonic intervals as equal spaces (*opposite*). Our senses grew on the harmonic substrate of the cosmos.

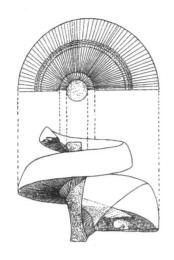

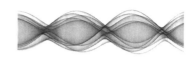

ABOVE: *A vibrating string displaying its typical sine wave shape, reminiscent of the shape of leaves and the movement of water. Image by Andrew David.*

LEFT: *Early twentieth century drawing of the cochlea, showing hairs inside this tiny part in the bony labyrinth of the inner ear as a series of harmonically diminishing lengths. Like a miniature church organ.*

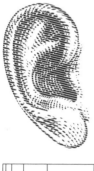

ACTUAL VIBRATION (*harmonic spacing*)

HEARD INTERVAL (*equally spaced*)

ACTUAL OBJECT (*equally spaced*)

VISUAL APPEARANCE (*harmonic spacing*)

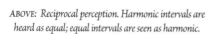

ABOVE: *Reciprocal perception. Harmonic intervals are heard as equal; equal intervals are seen as harmonic.*

RETURN TO THE ORIGIN
back to the point

The Diagram is an artifact of a unified science, an image of the mind of the Cosmos. It is Number. Number draws out our eternal nature, revealing itself through behaviours and qualities. It does not change, we change in relation to it, our discoveries, as Plato said, *'a heaven-sent ally in reducing to order and harmony any disharmony in the revolutions within us'*. Number is an impulse of universal love, giving freely, taking nothing.

The Pythagorean table (*below, and see page 19*), drawn with Lissajous figures in place of tone numbers, always returns to, or projects from, the mysterious point, source of all, both present and dimensionless, unmeasured and unmeasurable—a likeness of Eternity.

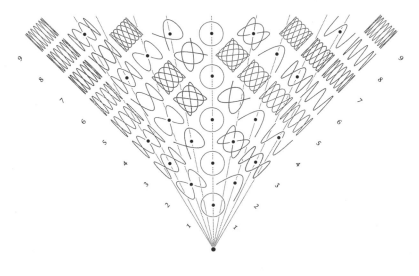